IMAGES
*of America*

# HOLBROOK

**ENTERING HOLBROOK.** Welcome, you are now entering Holbrook. We hope you enjoy your journey through Holbrook's history. (Photograph by Steve Conley.)

IMAGES
*of America*

# HOLBROOK

Holbrook Historical Society

ARCADIA

Published by Arcadia Publishing,
an imprint of Tempus Publishing Inc.
Portsmouth NH, Charleston SC, Chicago,
San Francisco

Printed in Great Britain

Library of Congress Catalog Card Number: 2003116188

For all general information, contact Arcadia Publishing:
Telephone 843-853-2070
Fax 843-853-0044
E-mail sales@arcadiapublishing.com
For customer service and orders:
Toll-free 1-888-313-2665

Visit us on the Internet at www.arcadiapublishing.com

*The Holbrook Historical Society gratefully dedicates this book to Wesley Cote, without whose widespread knowledge of Holbrook, its people, its geography, and its history (and his generosity in sharing that knowledge) we could not have produced this volume.*

# CONTENTS

# ACKNOWLEDGMENTS

It would have been impossible to produce this book without the help of many people.

Patrice Lynch acted as a writer and chairperson who coordinated layout and format with the publisher and researchers and writers Edna Bowers, Marion Colburn, Lt. David Kincus, Pauline Smith, and George Sullivan.

Our photographic help was provided by the very generous and skillful Steve Conley and by Lt. David Kincus of the fire department.

Many of the photographs came from the historical society's collection, donated over the last quarter century by innumerable people. Additional images were lent by Wesley Cote from his extensive collection; Jon Noren, the Holbrook Fire and Police Departments; the Holbrook Sun; the Patriot Ledger; and individuals who, when they heard of this project, called offering the use of pictures that were part of their families' heritages—thanks to them for rummaging through boxes and drawers for us.

The reminiscences and corroboration of dates came from the memories of people who patiently answered questions that must have seemed endless.

To all, we extend our grateful thanks. We hope you will think the result is worthwhile!

# INTRODUCTION

Our town, Holbrook, has the unique distinction of being the only town in the country to have a leap-year birthday. Once known as the East Randolph precinct, Holbrook was incorporated on February 29, 1872, after breaking away from Old Braintree. This was our beginning.

Before 1793, Holbrook, Randolph, Braintree, and Quincy comprised the old town of Braintree. Settlers moved into the area, and in 1724 roads were built in the southern part (now Holbrook and Randolph). Churches were established so that people would have a shorter distance to travel than to the center of Old Braintree.

In 1792, the area which is now Quincy split from Old Braintree. In 1793, Randolph became an independent town; this included the area of East Randolph, which is now Holbrook.

East Randolph became an active community. In 1775, East Randolph had its own company of Minutemen. (Seventy-five men served in the Revolution.) Businesses were established, including a gristmill, sawmill, blacksmith shops, and others needed for daily living. In 1878, the East Randolph residents petitioned for a separate parish church, making the area an official village.

In 1830, East Randolph organized its own volunteer fire department. Its own militia had been formed in 1811. (Thirteen men served in the War of 1812.) A library was built in 1832, and a post office in 1840. The railroad arrived in 1846. A church was built in East Randolph center in 1858. Factories for the manufacture of shoes were built starting in 1865. Many inhabitants were employed in the factories, but others remained farmers, millers, blacksmiths, and storekeepers.

The Civil War proved to be both tragic and beneficial for East Randolph. Of the 110 men who served, 25 died. However, four factories received government contracts for shoes and boots, which resulted in the expansion of the factories and financial advantage to the village. Holbrook presented the world with the invention of the aiglet, the tip of the shoelace that allows the lacing to go through the hole with ease.

New resident growth in the 1850s and 1860s led to the eventual decision to become independent from Randolph. Disagreements had been increasing for many years. In 1866, Randolph decided to modernize the town house. East Randolph violently opposed this, asserting that change was unnecessary and needlessly expensive and of no real advantage to East Randolph while increasing their tax burden. The work was done, however. This proved to be the first definite move toward separation of the two areas. In 1871, after several meetings, it was decided that East Randolph was substantial enough in population and wealth to support

itself. A petition was submitted to the legislature, and Elisha Niles Holbrook pledged to donate to the new town, provided incorporation was approved, the sum of $50,000—$25,000 for a town hall, $10,000 for the furnishing of a library, and $15,000 to pay off town debt. In January 1872, the hearing before the general court was a bitter one, with the Randolph faction strongly opposing the separation. The loss of income to Randolph would be considerable. The bill finally passed on February 29, 1872. Now, we are the town of Holbrook, so named in recognition of Mr. Holbrook's generosity. Sadly, he did not live to see the results of the lengthy debate. He died February 5, 1872. Holbrook comprises 7.3 square miles and is now home to approximately 11,000 residents.

From Elisha Holbrook, the founder of Holbrook, and George Spear, a shoe manufacturer and philanthropist, to Andrew Card, Pres. George W. Bush's chief of staff, and especially to our men and women of the armed forces, Holbrook has contributed greatly to this nation.

These photographs, compiled from the archives of the Holbrook Historical Society and other contributors, will take you on Holbrook's journey from the early 1700s to the present day.

# One

# PEOPLE

The most important part of any town is its people. Holbrook has a history of many generations of prominent families that have given support to the community. The Hookers, for example, go back more than 350 years in the area. According to Ann Hooker, their family came with a small group of settlers from Plymouth Plantation to begin the ironworks in 1639 and remained here to raise their families. In 1915, they started the Hooker Ice Cream Factory and supplied people not only with many years of enjoyment but also many men and boys with employment.

Elisha Niles Holbrook, our founder, was the philanthropist and businessman for whom the town was named. Many public buildings, such as the town hall and the public library, were recipients of his endowments. His mission was to see the people begin a new town free of debt. Unfortunately, he died February 5, 1872, but he had arranged his estate to fulfill his wishes if the town incorporated, which it did on February 29. His family carried on his philanthropic spirit.

The Austin family has given Holbrook five generations of firefighters, who have protected our lives and properties since 1872.

Holbrook High School class of 1965 graduate Andrew Card serves his town and country as the White House chief of staff for Pres. George W. Bush. Andy never forgets the town he grew up in. Even when his duties call him elsewhere. On November 23, 1990, the night of his 25th high school reunion, he called from Air Force One to say hello and that he wished he could be with the friends he grew up with.

Each generation makes its contributions to the community, and it takes a whole community to raise a child. Hence, like the circle of life, the next generation receives and contributes, and so forth. This chapter is just a sampling of those generous people, past and present.

Several years at the Holbrook High School Graduation, the principal has told the senior class that no matter where their futures take them they are only a phone call away. All they need to do is dial "H" for Holbrook. Someone will answer.

**ELISHA NILES HOLBROOK (1800–1872).** Elisha Niles Holbrook was the philanthropist and businessman after whom the town was named. He built a boot and shoe factory on the site of the present Holbrook Town Hall. Many public buildings, such as the town hall and the public library, were recipients of his endowments.

**A MAP OF WHERE PROMINENT FAMILIES WERE LOCATED.** It is so interesting to see where families lived. Note that many of the streets were named after them.

HOLBROOK

SETTLEMENT OF HOLBROOK, 1876

A COMMUNITY DEVELOPS:

**NOEL KING.** King was a popular town figure and selectman who entered the U.S. Army in 1941 and was killed in action on January 15, 1943. In the words of George Porter, "A few words about a man who entered the lives of us kids. His name was Noel King. A group of us young fellows played 'sandlot' football. No pads or helmet, the real game, not touch. Noel always entered in even though he was twice our ages. He also arranged some games with groups from other towns to play on Sunday afternoons. Even as I write this I remember what a great guy he was."

11

**ANDREW CARD JR.** Chief of staff to Pres. George W. Bush, Andrew Card Jr. is the oldest child of the five children of Joyce and Andy Card Sr. He is a *Mayflower* descendant through the lineage of both parents. The Card family goes back many generations in Holbrook and has always been active in town politics, committees, and events. Andy's political career started early as president of the Holbrook class of 1965. Never forgetting his roots, the Troop 13 Eagle Scout now serves us from Washington, D.C., returning to deliver commencement addresses, inspiring our young people. He is pictured here with Allan Gursney.

**WALTER OTIS CROOKER.** The town's first police chief died in 1933. He was buried in the town cemetery with a solid gold badge and an inscribed Smith and Wesson revolver that the town presented to him for his bravery in the famous Holbrook Square gunfight of 1903.

**MARY WALES HOLBROOK (1829–1906).** Mary, daughter of Elisha N. Holbrook, continued Elisha's generosity to the town. One such act of generosity was the donation of land that is known as Mary Wales Holbrook Park, in Holbrook Square.

**MARION AND BOB COLBURN.** Marion is chairperson of the Holbrook Historical Commission and one of the founders and past presidents of the Holbrook Historical Society. Marion has stated, "We are fighting to preserve what we have in Holbrook." Bob Colburn was extremely active as a selectman and Rotarian. Known as a people person, he instituted an exchange program for students and was on the Holbrook Community Development Committee, procuring grants for housing improvements in the community.

**HUGH SMITH.** Smith was the town assessor from 1959 until he died in 2001. He was honored by his fellow citizens with an unveiling ceremony of a portrait that now hangs in the town hall, where he worked many late hours preparing the financial budget—a difficult job he did with expertise, integrity, and love for the community.

**WES COTE.** Cote is a town historian and truly the man who knows everything there is to know about Holbrook. Wes, an avid collector of military memorabilia, started researching Holbrook's history in 1943 and has written and preserved volumes of information. He is shown here holding Holbrook's original 1917 honor roll. Thank you, Wes. (Courtesy of Wesley Cote collection.)

**LOUIS CHASE, KEEPING OUR COMMUNITY SAFE.** Louis Chase (shown c. 1949) was the forest-fire lookout for many years at the wooden watch tower situated 350 feet above sea level on Pine Street. Chase regularly climbed the 70 feet to his office with a spectacular 360-degree view of 20 miles. He was employed by the forestry division of the Massachusetts Department of Conservation and Recreation and worked approximately nine months a year from March to November, taking off rainy days. (Courtesy of Wesley Cote collection.)

**DR. FRANK W. CRAWFORD.** Crawford practiced medicine in Holbrook starting in 1912. He served as Holbrook town physician from his home and office at 100 North Franklin Street. He graduated cum laude from Tufts Medical College in 1909, was active in the American Legion, and served in the 77th Division during World War I. His office shingle now hangs in the Holbrook Historical Society.

**THE DORNAN BROTHERS.** Leo and Charlie Jr., noted entertainers known as the Gentlemen of Comedy, were featured on the Jack Paar Show, played in Las Vegas with Guy Lombardo, and performed their show all over the United States and on the high seas. A picture of their famous father and one of their playbills can be seen on page 119.

**FRANK AND GEORGE WHITE.** This is a wonderful picture of the White brothers as children. Frank was the founder and owner of White's Florist.

**WALTER CUSHMAN BELCHER.** Belcher, pictured here on active duty aboard a U.S. Coast Guard ship, was a graduate of Thayer Academy, Harvard University, and Massachusetts Institute of Technology. Belcher was a mining engineer, surveyor, and high school teacher.

**HOLBROOK TOWN OFFICERS.** This c. 1902 photograph shows, from left to right, the following: Fred C. Hollis, selectman; Fred W. Whitcomb, selectman; Charles E. Moore, selectman; George B. French, treasurer; and Louis E. Flye, town clerk.

**FRANK MCGAUGHEY.** McGaughey, pictured here on the left speaking with Governor Volpe, was the owner and editor of the *Holbrook Sun*. Frank served as town selectman for 19 years and town administrator for 7 years. In 1984, former governor Michael Dukakis appointed Frank chairman of the state Emergency Finance Board. When he died, the *Sun* reported that "Four qualities especially describe Frank. His service in government was marked by integrity, professionalism, intelligence and fiscal conservatism."

**JOHN KING.** John King was a selectman and the father of Noel King. Both father and son contributed greatly to their town.

**EVA SULLIVAN.** Eva is pictured here in front of Murphy's Blacksmith Shop. Visiting nurse Sullivan is given a ride by Phil Tierney on her first call of duty in 1919. Many residents still remember Eva visiting their homes when family members were ill.

**MARTHA CAREY (FEBRUARY 20, 1899–DECEMBER 13, 1982).** Carey was a benefactor, teacher, athlete, and world-champion baseball player. Martha is pictured here holding the team ball. She graduated from Sumner High School, Boston University, and Marietta College before serving as the director of physical education at Columbus School for Girls from 1938 to 1954. A scholarship in her name is presented each year to a board-selected senior at Holbrook High for continuing education. (Courtesy of Wesley Cote collection.)

# Two

# HISTORIC HOUSES

In the early 1700s, Holbrook was a wilderness open to settlement. The earliest house was built on Center Street in 1720. Early homes were Cape Cod style with the front door set in the center, flanked by two bays. In time, a kitchen ell was added to the rear of the building. The tavern of Capt. Nathaniel Belcher, pictured on page 23, is a good example of this style.

From 1775 to 1830, boot- and shoe-making, originally a cottage industry, began to flourish. Prosperity introduced larger Federal-style homes, such as the elegant Colonel Barnabas house at 185 Center Street (c. 1790); the William Curtis Jr. house, a much enlarged Cape, at 56 Union Street (c. 1780); and the two-story John Adams house at 225 South Franklin Street. These houses remain, although all slightly modified.

North Franklin Street displays the greatest concentration of two-story, hip-roofed Federal houses in town. Included are the Hunt-Thayer house at 157 North Franklin Street (c. 1820) and the Capt. Jonathan White house at 197 North Franklin Street (c. the early 1800s). Wealthy factory owners built magnificent homes clustered near the village square. The most elaborate was the Italianate-style mansion of Elisha Niles Holbrook, conspicuous with its cupola and spacious grounds.

The town's incorporation in the leap year of 1872 prompted a boom in residential development. The fine Italianate mansion of E. Everett Holbrook with its fountain gardens and outbuildings was prominent, as was the Hartwell Richardson–designed shingled-style mansion of industrialist George N. Spear. The Brookville area underwent considerable expansion in the late 19th and early 20th centuries, transforming from a farming village into a suburb on the fringe of industrial Brockton.

Overall, three types of dwellings emerged in Holbrook during the late industrial period (1872–1915) and were of the eclectic Victorian mode. Common were the gale-front cottages with full width or wraparound porches featuring decorative bargeboards in the facade gable bracketed at the porch posts or at the front-entry door hoods.

Post 1942, developments were formed, such as the Fairfield or Campanili Estates on Abington Avenue, formerly Poole's Farm. These low-cost homes were ranch style and built on cement slabs, ready for the returning veterans of World War II. The largest developments were seen in the Westdale Road area, along Rose Way and Damon Avenue, in Revere Acres, and along Holbrook Shore on Lake Holbrook. The latter were primarily summer cottages but later rebuilt as year-round residences.

**A Beautiful Home.** Eugene Snell is pictured here standing in front of his beautiful home with his prized horse. Note the gravel road.

**THE MANSION HOUSE OF ELISHA NILES HOLBROOK.** The wealthy factory owner for whom the town was named built this Italianate-style mansion in 1863. It was razed in 1922.

**THE BELCHER HOUSE.** This house was built by Capt. Nathaniel Belcher, a soldier of the French and Indian War in the 1750s and a captain in the Revolution. It was used as a country tavern and known as the Half Way House. It served as a stagecoach stop between Boston and Taunton, complete with straw bedding on the upstairs floor for sleeping. A sign outside the door swung and bore the caption "Food for Man and Beast."

**THE HOME OF CAPT. ELIHU ADAMS.** Capt. Elihu Adams, brother of Pres. John Adams, lived here on the land grant secured by John. Big Elm is one of the largest trees in the area and was planted in 1796 by Jesse Reed, an inventor, and the daughter-in-law of Captain Adams. President Adams made frequent visits to this home, which stood on the present site of D'Anns Restaurant. (Courtesy of Wesley Cote collection.)

**THE HOME OF DR. JOSEPH B. KINGSBURY.** Pictured here is the home of well-known physician Dr. Kingsbury. It is located on North Franklin Street and the corner of Linfield Street. (Courtesy of Wesley Cote collection.)

**THE HOME OF REV. JOSEPH ROBERTS.** This home was built on Roberts Hill along Roberts Road, off of Centre Street. Reverend Roberts drowned during the construction of the Sylvan Lake Dam, which controls the water that runs under Union Street to Sylvan Lake. This beautiful home was destroyed by fire in 1898. Reverend Roberts and George Chapin were part of the original Holbrook Land Company—a project of the 1870s that never materialized.

**THE PORTER HOMESTEAD AT 154 PLYMOUTH STREET (1770–1775).** The Porter Family was awarded their property with a king's grant from George III. The family settled in Old Braintree in 1770. Descendants of the Porter family still reside on Weymouth Street in Holbrook. The barn behind the house was originally the Bates Shoe Factory. A brief family history follows. John Porter (1786 to *c.* 1844) lived in his father's homestead at 154 Plymouth Street. He was a farmer, surveyor, carpenter, schoolmaster, representative to the general court, and, from 1829 to 1830, a selectmen of Old Randolph. John F. Porter (1827–1906), son of John P. Porter, returned to Massachusetts after schooling and traveling. He opened a stall in Faneuil Hall Market. He then started manufacturing boots in a small shop on Union Street below Mary Wales Holbrook Park. In that shop, boots were stitched by machine under factory conditions for the first time in this country. John W. Porter (1864–1941), son of John F. Porter, served as Holbrook selectman from 1899 to 1941 and town treasurer from 1925 to 1939.

**THE ISLAND HOUSE.** Matthew Pratt built this house in 1747 in the field south of the Lincoln School on Plymouth Street where the Kennedy School is now. The area to the rear of the school, now the superintendent of schools office, was known as "the Island," hence the house's name. Once known as the oldest house in Holbrook, the building was demolished 1909. (Courtesy of Wesley Cote collection.)

**THE EPHRAIM LINCOLN HOME (1817–1900).** Ephraim Lincoln lived here and owned the Lincoln Block across the street. He was the postmaster. Later, it was the home of East Randolph's first physician, Dr. Theophilus Emmons (1805–1871). He resided here until his death. Mrs. Stoddard ran a lunch room here *c.* 1930, and it was used as a classroom for a short time. The building was also used as the clubhouse for the William B. Dalton post of the American Legion. (Courtesy of Wesley Cote collection.)

**THE GEORGE N. SPEAR ESTATE.** The Spear Mansion was one of the showplaces of the town. Spear was a shoe manufacturer and philanthropist. His wife, Ellen, developed the Spear fund for the needy. The mansion was designed by Henry Walker Hartwell and William Cummings Richardson and built between 1882 and 1885. The house has been carefully restored and is currently home to an insurance agency.

**THE BOYHOOD HOME OF GEORGE M. LOVERING.** The home of Civil War hero George M. Lovering is shown on the left. Both of these houses were on North Franklin Street and were later moved to Belcher Street. (Courtesy of Wesley Cote collection.)

# Three
# BUSINESS AND INDUSTRY

Shoe manufacturing was an important industry in southeastern Massachusetts before the Civil War. Much of the business went to Europe and South America in the mid-20th century. Holbrook played an important part in boot- and shoe-making. There were a number of large factories: Thomas White and Company, Whitcomb and Paine, the Edmund White Company, Sears and Roebuck, Howard Platts and Paine, and the Monitor Shoe Company who sold the finest Colonial calf leather at $3.50 per pair. There was also an even larger number of small shoe-related businesses: Elisha W. Thayer on Linfield Street, the John Paine Company (the barn on the property had at least three work stations with sewing machines for the stitching of shoes), the Carlton Poole Heel Factory, and many home workshops where the owners, in addition to farming, did piece work on parts of shoes or assembled completed shoes.

Holbrook is also home to the invention of the aiglet—the hardened tip of a show lace which makes insertion into the eyelet easier. Even with the present widespread use of Velcro fasteners, this remains an important feature.

Shoe manufacturing employed many of the town's workers, and to support them there were dairy farms, general goods stores, meat and fish markets (Allan's made weekly rounds with a wagon from which residents purchased their supply of meat), a furniture store, a clothing store, and a pharmacy. Craftsmen, such as blacksmiths and carpenters, were also a necessary part of the community. A bicycle shop, a sawmill, and an icehouse all served vital functions as well.

Physicians (one of whom established a small hospital), lawyers, and bankers, were part of the town's business structure. The more affluent citizens—factory owners and such—employed dressmakers, coachmen, and gardeners.

In the early part of the 20th century, a small peanut-butter making business, Austin's, was established, and a large ice cream business, Hooker's, became an important fixture of the area.

In the ensuing years, particularly after World War II, the face of the town changed considerably. We are now largely a commuting society, working in other towns, but returning here each evening. The general goods store has become a supermarket, the blacksmith shop is now a gasoline station, and the sawmill and icehouse have given way to lumber yards and refrigerators. We buy our clothing and furniture elsewhere. Many of the differences can be attributed to the great changes in transportation and lifestyles. Nevertheless, Holbrook remains our base, and there are still businesses and workers to meet our needs.

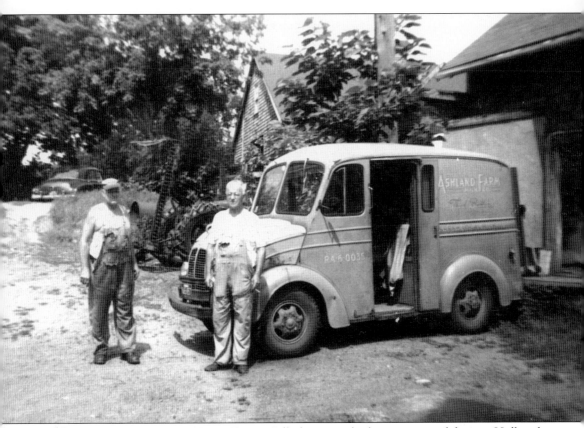

**THE END OF AN ERA: THE LAST FARM.** Gills farm was the last commercial farm in Holbrook. Pictured here from 1961 are the owners. Henry Gill is on the left, and William Gill is on the right.

**STOREFRONTS.** The present-day Holbrook Town Hall was rebuilt in 1879 on the site of the first building, which was destroyed by fire and has been home to a variety of different retail merchants throughout the years. These *c.* 1894 pictures show the storefronts of J. E. Nickerson Wallpapers and Paints and Hallett and Baxter Groceries on the ground floor.

**THE SHOE FACTORY.** Pictured here is the original Whitcomb and Paine Shoe Factory on North Franklin Street *c.* 1890. In the 19th century, New England was the center of shoe manufacturing. Fifty percent of the nation's total shoe production came from Massachusetts. Machinery did not play a large part in manufacturing until the 1850s. With this change the small custom shops, the 10-footers, as they were called, were abandoned as workers headed for the large factories that began cropping up.

**A VEGETABLE TRUCK.** Early in the 20th century, many store owners provided delivery service to their customers. Vegetable, meat, and fish were available this way. Generally, the driver followed a route that made it possible for homemakers to expect him on a specific day without placing an order. In other instances, a telephone order was placed and delivery made the following day. This method was a great convenience at a time when few owned cars.

**WILDE HARDWARE.** George T. Wilde sold groceries, hardware, flour, and grain and was located at Post Office Square in Holbrook when he was not on the road with his wares. Wilde apparently advertised on yardsticks, one of which can be seen at the historical society.

**THE ENGLISH DAIRY FARM.** The farm was located on the present-day site of Wright's Bowling Alley. (Courtesy of Wesley Cote collection.)

**FIRE AT ENGLISH DAIRY FARM, AUGUST 7, 1946.** The farm was located on Union Street. (Courtesy of Wesley Cote collection.)

**BOOT FACTORY.** The Thayer Boot Factory was located on Linfield Street and is pictured here in 1885. This picture really shows the flavor of a past era.

**HOOKER ICE CREAM.** The Hooker Family Farm was located on what is now Plymouth Street. During the Depression, Edwin Hooker's wife, Diena, had the idea to make ice cream to help with the finances. An ice-cream plant was built *c.* 1915 on the corner of Belcher and School Streets. It was truly a family affair. According to Wade Hooker, the two oldest sons, Alonzo and Louis, had their work cut out for them; they pedaled the bike that ran the machine to produce the ice cream. Grandfather Hooker also worked, peddling the ice cream to surrounding shoe factories with his team of horses.

**THE POST OFFICE.** Note the man standing ironically in the doorway of the post office with the sign reading, "Loafing Prohibited." Chief Walter Crooker carried the mail from the railroad station to the post office for many years. Pictured below is Mrs. Poole inside the post office in 1905.

**THE ICEHOUSE.** The ice operation was run by Lemuel Bagley and his son Clayton. They not only supplied Holbrook with ice but also the railroad for use in the Pullman cars. The icehouse stored 40,000 tons of ice. One hundred and twenty-five tons were shipped daily to Boston and Fall River. Families needing ice placed a small cardboard sign in their window to let the iceman know how much was needed. Located in the grove on Lake Holbrook, the business closed in the 1930s, when households started using refrigeration.

**WILLIAMS'S SAWMILL.** Williams's sawmill business, shown here *c.* 1913, was located on Union Street where Wright's Bowling is today. Owner Fred Williams tragically suffered a fatal accident when the logs avalanched and momentum pushed him into the saw.

**ANDY'S MARKET.** We can only surmise that this market may have been where people gathered to converse and relax on a weekend day while picking up food and supplies.

**THE HOSPITAL.** Elmhurst Hospital, founded by Dr. Arthur Cole, was located where the nursing home used to be. The area is now occupied by Allied Auto. The hospital was also a tuberculosis sanitarium. In his spare time, Dr. Cole acted as an arborist.

**McGaughey's Store.** Shown here *c.* 1900, McGaughey's store was owned by John R. McGaughey, whose wife's family held much of the property in the Johns Avenue and Division Street areas. After John retired, Frank McGaughey Sr. ran the store, which had gas pumps in front of it. McGaughey's Corner was a stop on the trolley line. Frank ran the store until 1939, at which time it became Katherine McGaughey O'Brien's. During World War II, the store was closed because of rationing. It later reopened, then closed permanently in 1962.

**The Milk Wagon.** A familiar and welcomed sight in every small town was the milkman. He satisfied everyone's need for the daily supply of milk, especially the growing children. Milk easily spoiled, so the milkman placed the order in an insulated box on people's doorsteps to ensure its protection from the sun, warm temperatures, and the occasional prowling animal. All who remember would agree that the milk was creamier back then and tasted great.

**WHITE'S FLORIST.** White's Florist was opened in 1895 by Frank White Sr., and descendants of the shops original customers still dial R-O-S-E-B-U-D to place orders for their special occasions.

**THE CYCLE CLUB.** This is a wonderful photograph of French's Bicycle Shop and Club, located on North Franklin Street. From left to right in front of the building are Mr. McLaughlin, unidentified, and Zenas French. Note the classic bicycles.

**OPENING DAY.** This picture was taken at Wrights Golf Driving Range on Union Street on opening day, June 12, 1959. Still in existence today, the bowling alley and driving range offers hours of entertainment for everyone. (Courtesy of Wesley Cote collection.)

**STANEY'S ICE CREAM.** A scene from opening day at Staney's Ice Cream on Union Street is shown here. The business started as an ice cream stand in June 1958. Staney's still operates as a family restaurant and ice cream parlor.(Courtesy of Wesley Cote collection.)

**FARMING.** Shown is a 1902 scene of haying on the Emery farm in the village of Brookville, the southern area of what is now Holbrook. Much of Brookville was a farming area until the early 1900s, when residential development began.

**THE LINCOLN BLOCK.** The Lincoln Block was built in 1817 by Ephraim Lincoln on the corner of South Franklin and Union Streets. Quarters of the property were given to the tailor C. E. Brown, to J. T. Southworth and Company in the 1890s, and to Thompson's Five and Dime in the 1950s.

**THE THOMAS WHITE COMPANY.** The Whites had the first steam-operated shoe factory. The building was located where Mary Wales Holbrook Park is now. It is said that Thomas White acquired the first telephone line in the area.

**THE BLACKSMITH SHOP.** Charles H. McCarte owned this blacksmith shop located on Plymouth Street. It is shown here *c.* the 1880s. (Courtesy of Wesley Cote collection.)

# *Four*
# TRANSPORTATION

The evolution of transportation has never been more evident than in the diary of town resident John Farrington Holbrook. John's journal was found in the attic of his father's house in Weymouth and was donated to the Holbrook Historical Society in 2001.

His one-line entries enlighten us on daily life back in the late 1890s, beginning with the day of his marriage to his wife, Jennie. The following are actual entries from the diary, which show various ways people traveled, as well as devastating accidents they encountered:

Tues. April 26, 1892—Franchise granted for Electric R. R.
Tues. Jan. 11, 1898—Mrs. Brewer fell from bicycle.
Thurs. Feb. 3, 1898—Stormy—Wrecks on shore and collision on B & M R. R.
Fri. Feb 4, 1898—Stormy—Electrics running at Brockton.
Tues. Feb. 8, 1898—Stormy—Electric road opened for first time in 10 days.
Tues. Feb. 22, 1898—Stormy—washouts on electric and steam roads.
Fri. Sept. 23, 1898—Stormy—Abby and Etta thrown from carriage.
Sat. Feb. 18, 1899—Cloudy—bad walking.
Fri. May 26, 1899—Pleasant—man injured and horse killed on car track.
Fri. August 4, 1899—Pleasant—woman killed by bicycle in Brockton.
Fri. April 6, 1900—Pleasant—Jennie went to Randolph, walked.
Sat. November 2, 1901—Pleasant—went after wood, broke wagon.
Wed. Mar. 25, 1903—Charles Porter killed by automobile.

One of the most important points in Holbrook's history is the opening of the Brockton and Holbrook electric trolley line in 1892. Thousands of people welcomed the streetcars in a grand celebration, complete with music by Harlow's Band, fire rockets, and church bells. The cars carried prominent invited guests for the length of the line during the maiden voyage and ended at the Holbrook Town Hall, where speeches were given. The grand night ended with a dance held in the town hall.

An extension to South Braintree was built in 1894. Although the trolley line was welcomed with open arms, its life was shortened by progress a mere 43 years later when motorized buses took over. On Friday, June 21, 1935, the last trolley car ran through Holbrook.

Changes in transportation have greatly influenced the workforce in town, and today there is a commuter train station located on Centre Street as part of the Randolph line.

**THE HORSE AND WAGON.** In the beginning, transportation was not fast, but the horse and wagon got the job done as seen in this picture of a hay wagon on Plymouth Street.

HOLBROOK'S FIRST STREETCAR. Behind the streetcar are the Lincoln Block, the Thomas White factory, and the town hall in this September 17, 1892, photograph. (Courtesy of Wesley Cote collection.)

HOLBROOK SQUARE LOOKING WEST. Note the fountain shown here in Holbrook Square c. 1900.

**STREETCARS.** Shown is a Brookville Baptist Church Sunday-school outing to Nantasket Beach *c.* 1905.

A MOTORCYCLE. Morris Sears and his motorbike are shown here *c*. 1910. (Courtesy of Wesley Cote collection.)

**INNOVATIVE TRANSPORTATION.** This young boy had the right idea. He hitched up his cow to pull his bicycle through Brookville Square *c*. 1900. (Courtesy of Wesley Cote collection.)

**A TEAM OF OXEN IN HOLBROOK SQUARE.** This is one of the earliest known pictures of Holbrook Square. A Brockton-bound coach is in the background.

**THE FIRST TAXI.** Shown is a vehicle from Ralph Wallace's Holbrook Taxi Company. (Courtesy of Wesley Cote collection.)

**AN EXPRESS TRUCK ACCIDENT.** This vehicle, owned by Chief Walter Crooker, collided with a Union Street telephone pole on May 28, 1915. (Courtesy of Wesley Cote collection.)

**HORSES AND TEAMS.** Shown is a *c.* 1910 crew working at the East Division Street construction of a new highway in Braintree Highlands. (Courtesy of Wesley Cote collection.)

**A HORSE-DRAWN SCRAPER.** This horse and carriage is working on North Franklin Street *c.* 1920. (Courtesy of Wesley Cote collection.)

THE HIGHWAY DEPARTMENT. A highway department crew is shown in 1959. (Courtesy of Wesley Cote collection.)

HOLBROOK PHARMACY. The bus stop at Holbrook center is pictured here *c.* 1945. Note the old pharmacy that has since been torn down.

**THE HOLBROOK RAILROAD STATION.** The station, shown here *c.* 1910, was located on the Randolph-Holbrook line. The top half of the station burned on November 11, 1933. Both the Holbrook and Randolph fire departments responded and fought the stubborn fire under the command of Chief Coulter (Holbrook) and Chief Bailey (Randolph). The remainder burned down in 1960.

**RUSH HOUR IN HOLBROOK SQUARE.** North Franklin Street is shown *c.* the 1930s in this view looking north toward Braintree, from the intersection of Route 37 (originally an Indian trail) and Route 139, which first became a road in 1753.

# Five

# HOUSES OF WORSHIP AND SCHOOLS

Through the years, Holbrook has had Christian churches of different denominations. Among the first was the Winthrop Congregational Church, which was established as a separate parish from its Randolph predecessor in 1818. The present church was founded in 1858. Brookville Baptist Church was dedicated in 1868, and the Chapel on the Hill in 1878. Danger of fire was always a great concern. The Winthrop Church, along with the adjacent town hall, was destroyed by fire on Christmas Eve in 1877 and rebuilt three years later. Although clergymen were often transferred to different parishes, many remained with their congregations for years, becoming an integral part of the community. In recent years, additional houses of worship have been established: Temple Beth Shalom, the Lighthouse Baptist Church, and Kingdom Hall of Jehovah's Witnesses. Pastors and assistants participate in discussions of the Bible on Holbrook Cable Television in a program entitled *The Living Word* and in less formal settings to resolve mutual concerns.

"School Days, School Days, Dear Old 'Golden Rule' Days." Currently, there are four operating schools in the town of Holbrook. However, there are four other buildings that were once used as schools, and three school buildings that no longer exist. Considering the relatively small size of our town, it is impressive that there have been 11 schools within our borders in the 131 years since incorporation.

Garfield, Lincoln, and Kennedy schools honor the memory of assassinated presidents, and the Charles Sumner school commemorated the highly respected senator from Massachusetts. The Lincoln School houses the administrative offices, the Garfield was destroyed by fire in the 1970s, and the Kennedy School is currently in use.

The Holbrook Police Station was originally the Franklin School, behind which was the Belcher School. The latter was a shoe factory owned by the Avon Sole Company and was converted to a school to avoid double sessions. The home of the Holbrook Historical Society on Union Street was once the Roberts School—the last one-room schoolhouse in operation in Massachusetts when it closed.

Between 1969 and 1970, the Brookville School (built in 1920) was demolished. It stood on the present location of the Brookville Fire Station. The remaining three schools—Saint Joseph's, the South Elementary, and the junior-senior high school—continue to educate the children of Holbrook, along with the Kennedy Elementary School.

**THE CHAPEL ON THE HILL.** This simple one-room wooden chapel, dedicated in 1878, was built to accommodate the people living in the area of Weymouth and Sycamore Streets. In 1913, the congregation was composed of Congregationalists and Methodists but had no permanent pastor. The building was later sold and moved to Pine Street and became a private home.

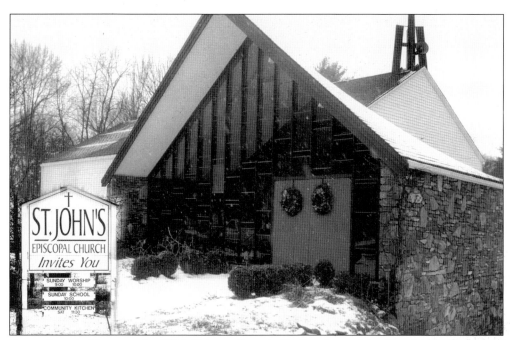

**SAINT JOHN'S CHURCH.** In 1914, Episcopalians in Holbrook worshiped in the old Knights of Pythias Hall in the square with Pastor Kenneth McLean. A building occupied by R. A. Weeks Oil Company was purchased *c.* 1917. The parish grew in numbers, and in 1953, land was donated on South Franklin Street where the present church now stands. The parish facilitates many charitable activities including free lunches and a food pantry.

**THE WINTHROP CONGREGATIONAL CHURCH.** The precursor to the Winthrop Church was the Second Church in Randolph, organized in 1818 in East Randolph. The building was erected on the grounds now know as Mary Wales Holbrook Park. Differences arose and a new society was formed, named in honor of Governor Winthrop. Due to membership growth, another church was erected on the corner of North Franklin and Linfield Streets in 1858.

**SAINT JOSEPH'S CATHOLIC CHURCH.** Saint Joseph's is shown here c. 1910. It was established as a parish in 1887. Until then, Holbrook Catholics traveled two miles to St. Mary's in Randolph. The First Pastor, Fr. James J. Kelly, celebrated Mass in Holbrook Town Hall. The church has many social organizations; a few of them include the Josepheens, Catholic Youth Organization, and St. Joseph's Sodality. The Daughters of Charity accepted a teaching assignment at the St. Joseph's Parochial School, which opened in 1962, and remains an elementary parish school today.

**INSIDE THE WINTHROP.** This picture shows the present interior of the Winthrop Congregational Church. Note the beauty of the wood. This church was destroyed by a fire that originated in the town hall next-door. The Winthrop was rebuilt and dedicated in 1880, and a beautiful new steeple was dedicated in the spring of 2003.

**FIRST COMMUNION.** Shown here is the First Communion day celebration at St. Joseph's Church *c.* 1914. On the right is Fr. John A. Sheridan, the fifth pastor of the parish. It was Father Sheridan that appealed for permission to have the upper church completed in 1916. He was successful, and on Christmas Day 1916, Mass was celebrated for the first time in the upper church.

**THE LIGHTHOUSE BAPTIST CHURCH.** This congregation was founded by Rev. Bruce Turner and his wife in 1974 as the Braintree Baptist Temple. Services were held in Braintree Highlands, and in 1978, the temple merged with Calvary Baptist Church and opened the Baptist Temple Christian Academy. To accommodate a growing membership, land was purchased in Holbrook and the building was completed in 1981. In January of 2002, the name was changed to Lighthouse Baptist Church.

**THE HOLBROOK UNITED METHODIST CHURCH.** In July of 1878, Methodism came to Holbrook in the form of a class-style meeting of 12 people who gathered in members homes. When the church was officially organized and named the Methodist Episcopal Church, worship was held in Library Hall, a small building behind the town hall that was destroyed by fire in 1880. After holding services for two years in the town hall, a church was built on Plymouth Street and dedicated in 1882. Many social and aid organizations were formed and a vacation bible school was established in cooperation with other town churches. The present brick building was dedicated as the United Methodist Church of Holbrook in 1967. In 1979, the church became a teaching parish and has welcomed many student ministers under the supervision of the pastors.

**THE BROOKVILLE BAPTIST CHURCH.** Although this congregation was founded in 1968, the church building was not dedicated until June 25, 1872. An annex was added in 1902. Lightning damaged the steeple in August 1949, which started a series of improvements and alterations. In 1957, extensive renovation and expansion was planned; the additions were dedicated in May 1958. Since that time, the church has become increasingly active, and its congregation now includes members from area towns.

**THE KINGDOM HALL.** Shown here is the Kingdom Hall of the Jehovah's Witnesses on North Franklin Street. This hall was built by the membership in one weekend.

**THE TEMPLE BETH SHALOM.** In January 1967, the former Methodist Church at 85 Plymouth Street was purchased and named the Jewish Community Center. Services were conducted by rabbinical students and cantors. Rabbi Elliot Hurvitz came in 1972 and is still serving the congregation of Holbrook residents and many from surrounding towns. Services are held on Friday evenings and Jewish holy days. Instruction is given to young students, and of course, special services are held for Bar Mitzvahs and Bat Mitzvahs.

**SUMNER HIGH.** Sumner High School honors the memory of a highly respected senator from Massachusetts, Charles Sumner. Senator Sumner was a radical abolitionist but is known less well for the part he played in the acquisition of our 49th state, Alaska. It was he who was sent by President Lincoln's secretary of state, William Seward, to investigate Russian America. His favorable report helped persuade congress to buy the territory. The picture above shows Sumner High *c.* 1913 being painted, and the picture below is the reunion of the class of 1917.

**CHILDREN AT THE FRANKLIN SCHOOL.** This *c.* 1900 photograph shows the second of three schools on this site. This one was built in 1882, the present school (seen on page 69) was built in 1932. Note the children sitting in the windows—something you would never see today.

**THE ROBERTS SCHOOL.** The present-day home of the Holbrook Historical Society was possibly the oldest one-room schoolhouse still functioning in Massachusetts until it closed its doors in June 1979, when it operated as a kindergarten. Today, the society opens doors to third graders each year for a week-long program where they are transported back to 1873, the year the little red schoolhouse first opened. The society holds several events throughout the year at the schoolhouse, such as the annual Strawberry Festival, speeches given by re-enactors of historical figures, and open exhibits from its archives, to name a few. (Courtesy of the *Patriot Ledger*.)

**STEPS BACK IN TIME.** As part of their study of local history, Holbrook's third graders spend one school day at the Roberts School in an atmosphere as nearly like a schoolroom from 1873 as possible. The classes are conducted using period textbooks, individual slates, and steel-tipped pens. At recess the games are those of the 1800s. The picture above shows the costumed children in class, and in the picture below, at recess making a cat's cradle.

**THE LINCOLN SCHOOL.** The Lincoln School (1851–1852), also known as Randolph District No. 2, burned and was replaced in 1902. The current building is home to the superintendents office. This *c.* 1935 photograph shows, from left to right, the following: (first row) Audrey Bond, Bill Austin, Bette Lavangie, T. Cassani, Louise Poole, Priscilla Hobart, R. Esterbrock, and Louise Cann; (second row) Bruce ?, Leroy Leonard, Ray Therman, Evelyn Cassani, Kenn Loud, and Ron Whitaker; (third row) Mary Carabedian, Ed Loud, R. Stokinger, Al Loud, and unidentified.

**A LINCOLN SCHOOL CLASS.** Children are shown here with their teacher on the steps of the Lincoln School. The date is unknown.

**THE FRANKLIN SCHOOL.** The Franklin School was built in 1932 to replace the wooden structure that was razed the same year. It was last used as a school in June of 1981. The building was then used as the police station but was abandoned again as it made way for a new 2004 safety complex.

**THE SUMNER SCHOOL'S SEVENTH GRADE CLASS.** This wonderful *c.* 1910 photograph was donated by Russell Chapman's daughter Priscilla Chapman Cedrone.

**JUNIOR AND SENIOR HIGH SCHOOL.**
The school located on South Franklin
Street was built in 1954. Pictured here
is a band concert c. 1970s. The
yearbook's name is Echo, and even in
its beginning issues, it echoes the
closeness of classes that grew up and
graduated together, recording the
successes and dreams for the future. The
high school offers many activities
beyond academics, such as clubs, sports,
plays, educational trips, and concerts.

**CELEBRATING GEORGE WASHINGTON.** Shown here is a class at the Roberts School celebrating
Washington's birthday. Note that the boy on the far left is none other than our town historian,
Wes Cote.

# Six

# CLUBS AND SPORTS

Whether we like it or not (and most of us like it), nearly all recreational and cultural activities take a backseat to sports. How many of us are willing to swathe ourselves in layers of warm clothing topped by hats and earmuffs to sit outside in freezing weather to watch the Boston Ballet or a Broadway play? Yet, look at the stands at a Patriots game in similar conditions, not to mention the annual high school Thanksgiving competition. Interesting!

Baseball, football, hockey, basketball, soccer—you name it and Holbrook has it and has had it since incorporation. There are numerous photographic records of our teams, almost since the invention of photography.

In December 1997, Warren "Skip" Webber wrote an article for the *Holbrook Sun* entitled "A Tip of the Hat to the Old Town Team," in which he recalled sporting events of 65 years earlier when he was a young lad. He names several of the old teams including the Holbrook Town Team and the Brookville Hockey Team. Also mentioned are many of the players and managers to whom he gives a moving tribute with the following words:

> What a great town to live and grow up in with these dedicated men supplying wonderful role models for us young people. . . . The small town spark is still alive and glowing bright as evidenced by the dedication and dreams of Mary Megley and Linda Canniff and the wonderful new playground they worked for and made a reality.

I know that he speaks for many of us.

Many of the sports organizations were exclusively male, whereas several clubs were composed of only women and several were composed of both men and women. The pictures in the following pages depict the Friendship Club and various women's organizations. Young people formed the Holbrook Fife and Drum Corps, the Knights of Pythias, and the Foggy Dew Club, which were entirely made up of men. These clubs performed many plays and variety shows in the auditorium at the town hall and brought many hours of enjoyment to the townspeople.

**EARLE HANSON.** Earle, shown here *c.* 1913, was a professional ball player from Holbrook who once played for the Chicago Cubs.

THE HOLBROOK AA FOOTBALL TEAM, THANKSGIVING MORNING. Shown in this 1907 photograph are, from left to right, as follows: Ed Galvin, Jack Sullivan, Clarence Pike, Arthur Pierson, John McKinley, Alonzo Hooker, Harry Starr, George Webber, Billy McLaughlin, Harry Lindsey, Frank McGaughey, Charles Pike, and Warren Simmons.

THE BROOKVILLE HOCKEY CLUB. This impressive hockey team picture was taken in January 1931. (Courtesy of Wesley Cote collection.)

**THE HOLBROOK BASEBALL CLUB.** The Holbrook Baseball Club is shown here from 1886. How uniform fashion has changed!

**THE PIONEER ATHLETIC ASSOCIATION.** This club, shown here *c.* the late 1800s, formed approximately 118 years ago and laid the foundation for future sports organizations in Holbrook. The association's mission was to promote popular and healthy sports, to do charitable deeds when needed, and to increase sociability of its membership, which was limited to single young men.

**THE ROTARY.** The Rotary Club was founded on May 15, 1955, and its members are local professional people with a common interest in community service and improvement. Meeting weekly, they have been instrumental in aiding the fire and police departments, schools, and the historical society by providing equipment and other needs. The Rotarians sponsor a little league team and scholarships for college each year. They founded and ran the student exchange program for 15 years. (Courtesy of the Rotary Club, composite by Steve Conley.)

**THE COCHATO CAMPFIRE GIRLS.** This great c. 1930 picture of the girls was donated by the Hayden Family. From left to right are the following: (first row) Dorothy Hayden, Catherine Butler, Evelyn Wallace, and Anna Ellis; (second row) Alma Hollis, Ruth Hayden, Gladys Dunham, Hattie MacCunnach, and Bernice Ballum.

**THE BASEBALL TEAM, THE CENTRAL SOCIAL CLUB.** Pictured above is the baseball team of 1909. Baseball had an important role in town, and games were a community social event. Below is the team the following year, 1910.

**THE FOGGY DEW CLUB.** The male social club, the Foggy Dew Club, is shown here *c.* 1902. The group met in an old barn behind where the Holbrook Manor Nursing Home was located. Mainly a social club, they occasionally put on minstrel shows that they performed at the town hall. Shown in this photograph are, from left to right, as follows: (first row) William Bates, Henry Thayer, Arthur Biglow, Russel White, Willie Rice, and Frank Hayden; (second row) Harry Barrows, Frank White, Fred Paine, George Porter, Hallet Thayer, George Dixon, and Walter Wilde; (third row) Willie Fouche, Dick Porter, and Walter Lincoln; (fourth row) Bert Wilde, Ira Paine, Fred Thayer, Royal Paine, Irving Dyer, and Arthur Pratt; (fifth row) ? Harvey, Frank Thayer, ? Bugbee, Frank Reed, Louis Fly, Charley Brooks, and George Harvey.

**HOLBROOK'S FIRST BOY SCOUT TROOP.** Pictured in this *c.* 1913 photograph is Holbrook's first boy scout troop. Currently there are two active troops in town: Troop 13 and Troop 56. (Courtesy of Wesley Cote collection.)

**THE HOLBROOK BOY SCOUTS' EISENHOWER PAPER DRIVE.** The boy scouts shown here *c.* 1945 are, from left to right, Tom Veale, Ted Veale, Tom Worth, Alan Loud, and Andy Card Sr. From the stack of papers behind the boys, its seems to have been a very successful drive.

**THE BROWNIES.** Pictured above is a group of boys called the Brownies. When the United States entered World War I, children served on the home front by selling defense bonds, working in hospitals, growing vegetables, and filling other community needs instead of hiking and taking part in outdoor sports. Below are the Brownies pictured in a car. Unfortunately there is no information known about these pictures in the archives, but they are delightful enough to tell their own story.

**THE HOLBROOK GIRL SCOUTS.** The young scouts pose here with Scout Mistress Emma Hall *c.* 1919. (Courtesy of Wesley Cote collection.)

**THE HOLBROOK BAND.** Today, we are still blessed with a wonderful band, present at all town special events.

**T-BALL.** Pictured here are a group of young athletes and their coaches sponsored by Andy's Auto. Holbrook hosts T-ball as a fun, non-competitive introduction to sports, and the rules of baseball, for boys and girls.

**THE MINGO LANE ROD AND GUN CLUB.** The club, shown here *c.* 1900, was located on Mingo Lane, the present-day Division Street on the Braintree line. (Courtesy of Wesley Cote collection.)

**THE HOLBROOK MASONIC TEMPLE CLUB.** Shown at the Masonic temple *c.* 1930 are, from left to right, the following: (first row) Charlie Simmons (selectman), and John Porter (town treasurer); (second row) Charles Brooks, Al Magaw (town treasurer), George Nason (fire chief), Ralph Bates (assessor), Fred Gardner, Ernest Rogers, and Dave Forest; (third row) George Porter (selectman), Frank Chapman (selectman), Roy Smith (representative to the general court), Frank Reed, Walter W. Lincoln, and Lester Holbrook (tax collector).

**ON PARADE.** The Friendship Club is shown here at Winthrop Congregational Church on a decorated float pulled by an ox.

COSTUME NIGHT. The members of the Friendship Club are shown at the Winthrop Congregational Church. From left to right are the following: (first row) Kathleen Southworth, Minnie Magaw, Grace Porter, Mildred Howard, Grace White, Xene Holbrook, and Edith Cowie; (second row) Alice Wilde, Georgie Holbrook, Martha White, Carie Watson, Florence Towns, Millie Paine, Anne Crawford, and Nel Packard; (third row) May Wilde, Marion Roberts, Josephine Lincoln, Clara Poole, and Florence Lucas; (fourth row) Helen Thayer.

**THE KING'S DAUGHTERS' JAZZOBO BAND.** The King's Daughters' Jazzobo Band is shown here in the Winthrop church vestry on December 11, 1917, during a World War I patriotic event. The King's Daughters are a charitable organization of women, originally under the financial sponsorship of King Louis XIV. It originated in Canada; some members later migrated to the United States where chapters were established in churches of various denominations. Each circle adopted a resident of an old folks home to help and provide necessities and small luxuries for. Holbrook resident Mrs. Poole, mother of Virginia Holmes, was an active member of the Jazzobo Band.

**THE CHORUS LINE.** Seen here in the Winthrop Club Minstrel Show from 1957 are, from left to right, as follows: Lester Leonard, Chief of Police Charles Williams, John Towns, Harold Casperson, and Andrew Card Sr.

# Seven

# COMMUNITY EVENTS

Like most communities, Holbrook has marked special occasions with parades, speeches, games, or other observances; some of these are solemn, some joyful.

Memorial Day has always been important here. Even before Holbrook became a separate town, there was a procession in East Randolph honoring the occasion. That tradition has continued to the present day.

The eve of Independence Day, from 1951 to 1968, was always the occasion for a large bonfire to celebrate the Fourth of July. The most elaborate Fourth of July celebrations took place in 1916. In that year the Independence Day observance was coupled with Holbrook Day, saluting philanthropist E. Everett Holbrook. Mr. Holbrook made many generous gifts to the town named in honor of his father. The parade on that occasion was more than a mile in length.

The opening of a new library building on Plymouth Street in November 1967 was accomplished by a book brigade of 1,000 elementary schoolchildren transferring the books from the former library in town hall.

Our centennial year, 1972, was celebrated in grand style. In August of 1971, the first time capsule was removed from the town hall cornerstone and its contents examined. A new capsule was prepared and laid in place on June 17, 1972. From that August event until the closing parade on June 18, 1972, a succession of observances were held: a community potluck supper, a special painting of the town's past, a gala dinner, two gala balls, and a firemen's muster.

The centennial celebrations proved that Holbrook does love a party. Every February of every leap year since 1972 has been marked with a gala dinner—a special birthday party for a special town.

Four years later, in 1976, our nation's bicentennial initiated other special events, such as dinners, balls, and a large parade. The schools played an important role that year, and our patriotism was evidenced by flags and bunting on almost every building. Also, 1976 saw the beginnings of the Holbrook Historical Society.

In 1979, another Holbrook tradition was established. The Holbrook Historical Commission started what has become the annual Festival of the Lights. On an early December evening, the seasonal tree and wreaths are illuminated upon chairman Marion Colburn's command: "Let there be light!"

Much of the New England spirit is embodied in Holbrook, and community celebration and solemnities are expressions of that spirit.

**THE BONFIRE.** In 1951, the first of the "night-before-the-Fourth bonfires" was built by Holbrook firefighters and volunteers. The tower was constructed of creosoted railroad ties and other discarded lumber. Under the careful supervision of the firemen, it was lit after darkness fell accompanied by the cheers of the many spectators. Because of environmental concerns, the custom was discontinued in 1968.

**THE TRADITIONAL MAYPOLE DANCERS, SOUTH FRANKLIN STREET.** The Holbrook Playground, shown here c. 1916, was given to the town through the generosity of E. Everett Holbrook, a town benefactor who continued the philanthropic spirit of his family.

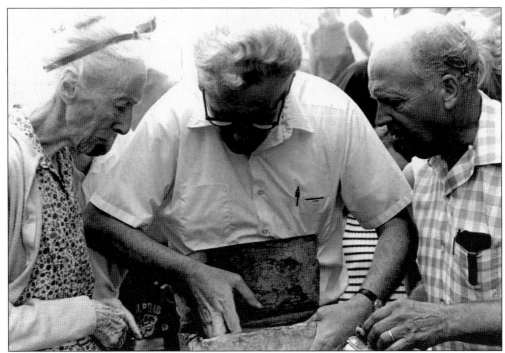

**AS TIME GOES BY.** On August 11, 1971, everyone wondered what would be discovered as the original time capsule was removed from the cornerstone of town hall. Shown in this photograph on that day are, from left to right, Bertha Cote (the oldest living resident at that time at 100 years old), Frank McGaughey, and Merton Mann. This original time capsule contained many items, including town records, local business cards, and newspapers. It is now in the Holbrook Historical Commission's office. (Photograph by Stan Collins.)

**A FOURTH OF JULY OBSERVANCE.** People are shown here celebrating at the Carlton Poole Heel Factory. It was an important part of the shoe manufacturing industry, the basis for Holbrook's economy.

**THE BOOK BRIGADE.** Some 1,000 elementary school children lined up to transfer books from the former library in the town hall to the new building on Plymouth Street in November 1967.

**A FOURTH OF JULY PARADE.** Shown is the great parade of 1916.

**MEMORIAL DAY 2001 AND FLAG DAY.** Until 1931, the annual Memorial Day observance was organized by the Sons of Union Veterans. That year the American Legion offered to take on the task but was rebuffed. To avoid a confrontation, two parades were held. Much to the delight of the town's children, each parade was followed by ice cream served to all present. The significance of the day may not have been apparent to the children, but it remained a memorable occasion. In 1965, second-grade teacher Anne "Tippy" Harrison inaugurated the Flag Day observance, which has become a tradition at the Kennedy School. She felt strongly that the children should know and respect the flag and its significance. Since that time the ceremony has grown in size and prominence. People from all ranks of local and state officials have been speakers and guests, and coverage has been broadcast in Boston and, on one occasion, in the national media reported by Dan Rather. (Photographs by Steve Conley.)

Corrections to "Images of America-HOLBROOK"

Page 12, line 7...Allen "Gursney", should be <u>Allen Gersony</u>

Page 16, top photo..."George Mason Lovering" and caption following, should be
<u>"E. Everett Holbrook, son of town's founder and generous donor to town</u>
<u>causes."</u>

Page 43 , bottom photo, lines 1 and 2... "Staney's" should be <u>Stanney's</u>

Page 62, bottom photo, line 1..."1968" should be <u>1868</u>

Page 95, bottom photo, lines 1 and 2...Walter "Cooker" should be <u>Walter Crooker</u>

Page 99, top photo...add <u>"Firefighter is Carl H. Miles with his daughter Charlotte."</u>

Page 112, Top photo, line 3..."George Kent" should be <u>Frederick Nelson Bigelow</u>

Page 123, top photo, line 3..."Nell Connelly" should be <u>Shirley Austin</u>

# Eight

# FIRE AND POLICE

In 1872, Holbrook was no longer East Randolph and established two fire companies. The Aquarius Engine Company of 20 members in Holbrook Square operated a hand-drawn pumper and hose reel. The Washington Engine Company No. 2 was situated in Brookville and similarly equipped.

As the community grew, it became necessary to improve operations. A new station was built in 1881 next to town hall. This building, still in use, is among the oldest operating fire stations in Massachusetts. Eventually, horse-drawn wagons replaced the hand-drawn pumpers. In the 1920s, all horse-drawn fire apparatus was replaced with motorized equipment. In the 1950s, the Board of Fire Engineers was replaced by a single full-time chief, and the number of full-time firefighters was increased to six.

As the population of the town has grown, so has the fire department and its responsibilities. In 1976, the department took over ambulance service for the town. At present the complement is 26 members, including the chief, his secretary, 4 lieutenants, 16 firefighters (8 of whom are paramedics), and 4 dispatchers. The equipment now consists of three pumping engines, one ladder truck, two ambulances, and several support vehicles.

The police department has been as much affected by the town's growth as the fire department. Its personnel increased from one part-time chief (Walter Crooker, who served in 1903–1928 and 1929–1933 and also carried the mail from the railroad station to the post office) to the present complement of 19, including the chief. In 1950, with a population of about 3,200, it was deemed necessary to add a patrolman, and in 1952, a second patrolman increased the number to three.

Police headquarters was housed in the lower town hall. When the Franklin School was no longer utilized by the school department, police headquarters was moved to part of the old school, where it has remained to the present time.

The great increase in automobile and truck traffic and the large number of medical calls, in addition to the many other public safety concerns, has made an improved headquarters for the fire and police departments a necessity. Combining communication and other technologies in a single facility and garaging all equipment at one site will improve efficiency and economy. On December 18, 2003, ground was broken for a new public safety building.

THE GROUNDBREAKING. Pictured here is the site for the new public safety complex. Construction workers broke ground in December 2003 and anticipated completion of the project for the late fall of 2004. Located on the corner of South Franklin Street and King Road, the complex will be a 25,000-square-foot building that not only will centralize and house the fire and police departments but also have space for training and for public meetings. The fate of the three buildings currently being used has not been decided.

**SAMUEL L. WHITE.** This prestigious-looking man was Holbrook's first constable and held his position from 1872 to 1884.

**THE CHIEF OF POLICE, WALTER COOKER.** Shown directing traffic in Holbrook Square is Walter Cooker, the town's former chief of police, and at the time only policeman, serving as a part-time peace officer. In an exchange of gunfire at the post office on a winter night, while he was partially concealed behind a telephone pole, a bullet pinched his long coattail. The robbers fled down Union Street toward Randolph in a sleigh and were never caught. Chief Crooker received a new pistol for his bravery in the face of fire.

**THE MOTORCYCLE POLICE.** Chief Edgar C. Hill is shown here on his motorbike in 1928.

**Teaching the Children.** Pictured here with Holbrook children, who he loved, is officer Thomas J. Fitzgerald (April 27, 1943–January 12, 2000), who sadly lost his battle to cancer in 2000.

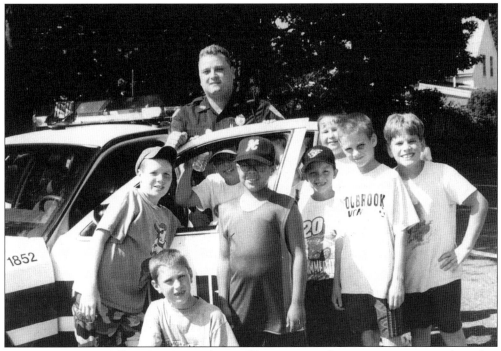

**Future Officers.** Officer Pat Quinn shows off his cruiser at the recreation program that takes place each summer at Sumner Field. The police department has a wonderful Web site listing all their programs.

**HELPING SANTA.** Pictured here in front of the current Holbrook Police Station is officer Dwight Burns, helping Santa prepare for a visit.

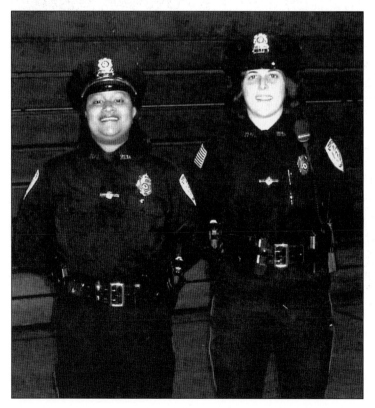

**POLICE OFFICERS.** On the left is officer Keysha Bowen and on the right is officer Jeanine Matott. The mission statement of the Holbrook Police Department is to create a feeling of safety and security in all of our citizens by providing the best quality law enforcement service possible. The Holbrook Police Department is committed to fair, professional, and equal service and treatment for all citizens.

THE FIRST FIREFIGHTER. In 1920, the town of Holbrook purchased its motor-driven fire engine. It was a combination 1920 Oldsmobile and equipped with a 40-gallon water tank. It carried 1,000 feet of regulation fire hose. At the same time, the town hired its permanent firefighter. Seen here is the first firefighter on his way home for a meal hour with his daughter and his dog. This individual was required to work from Monday morning through Friday evening. He was allowed three meal hours each day and was required to take the truck home during his meals.

THE WASHINGTON. Members of Hose Company No. 2 would drill with their hand-operated pumping engine, called the Washington No. 2, every Sunday morning during the first decade of the 20th century. In order to provide an adequate stream with a minimum of 15 to 20 feet, they would raise and lower the side bars rapidly. The Washington No. 2 is currently owned by a private party in Newbury, Massachusetts. The Washington has the distinction of being the oldest firefighting antique owned by Holbrook and still in existence.

**A PROUD COMPANY.** Members of Hose No. 2 are shown here assembled for a group photograph in 1905. The company consisted of 15 members that used a single horse-drawn wagon, which carried a 1,000-foot fire hose and a hand-operated pump to fires.

**BROOKVILLE.** The Brookville fire station was built in 1868 as a combination schoolhouse and fire station. Located on South Street near South Franklin Street, the building served as the home of Hose Company No. 2 and in later years was called Holbrook Fire Station No. 2. In 1972, a new fire station was built next door and the old one was demolished to make room for the new station's parking lot.

**THE FIRST MOTORIZED FIRE TRUCK.** In 1920, Hose Company No. 2, located in the Brookville section, received their first motorized fire truck. This 1920 Ford hose wagon was used to protect the property within District 2 and assist at serious fires in District 1.

**A PHOTOGRAPH ON MEMORIAL DAY.** Members of Hose and Ladder Company No. 1 gather in front of Fire Station No. 1 for a group photograph on Memorial Day 1908. Built in 1881, Station No. 1 still serves as an active fire station and is considered to be one of the oldest operating fire stations in Massachusetts.

**The Town Hall Fire.** On February 28, 1897, members of Hose and Ladder Company No. 1 responded to a fire inside the Holbrook Town Hall, adjacent to their quarters. With difficulty, firefighters were able to contain the fire to two floors. A second alarm was sounded, bringing Hose Company No. 2 from the Brookville fire station to assist in control and final extinguishment. The building sustained $11,000 of damage and the cause was listed as accidental.

**A CLASSIC PICTURE.** The three fire trucks that normally responded from Fire Station No. 1 are on display in this 1946 picture. Each piece of fire apparatus had a specific job. Engine No. 1 is a 1924 Maxim pumper and was used for structure fires. Ladder No. 1 is a 1937 Maxim ladder truck and provided the ladders necessary at large building fires. Combination No. 3 was the department's forest-fire truck. The 1930 Chevrolet forest-fire truck still exists and is owned by an Ohio resident.

**THE FULL FORCE.** Standing in front of their fire trucks are all of the permanent members of the Holbrook Fire Department that were employed during 1957. Shown in this photograph are, from left to right, as follows: David Dobson, Donald Austin, Robert Crandlemere, George Austin, Chief Clifton Baker Jr., John West, Albert Woodman, Warren Alden, and Herbert Tucker.

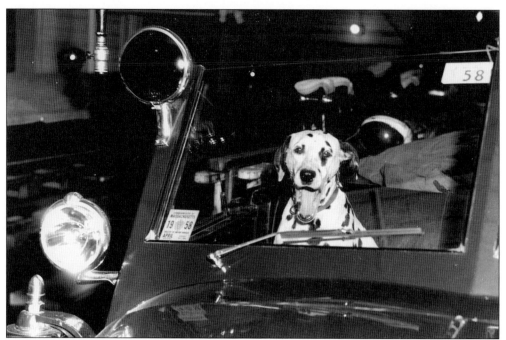

**MAN'S BEST FRIEND.** One very important member of the Holbrook Fire Department was Spanner the Dalmatian. Spanner accompanied the firefighters to virtually every fire the department responded to for close to two decades. Due to age, Spanner stopped responding to alarms in the mid-1960s.

**TONY.** Tony was the only horse owned by the fire department. A stable was built on the back of the fire station in order to house him. Additional horses were obtained from a stable located near the station in the event of a fire. Upon Tony's retirement, the horse stalls were converted into living quarters for the firefighters.

# Nine

# MILITARY

Soldier's Monument was the first memorial in Mary Wales Holbrook Park. It was dedicated on May 30, 1917, and carries the names of those who lost their lives during the Civil War. Also engraved on this stone is the name of Elihu Adams, brother of John Adams, the nation's second president. Later, two memorials were placed at the sides of Soldier's Monument and were dedicated to those who served in all branches of service in subsequent wars.

The contributions of these men and women should never be forgotten and we hope these pictures enlighten and inform you of their brave actions. Holbrook was home to a recipient of the Congressional Medal of Honor, George M. Lovering, who received the nation's highest honor for action during the Civil War.

King Road is named for Noel King, who served us not only as an honored selectman but also oversees in World War II. He died in a Japanese bombing raid on January 15, 1943, in Guadalcanal—his final resting place.

During the years of 1943 through 1945, the world was in the midst of this great war and residents wanted to support the 400 servicemen from Holbrook. The Servicemen's Gift Committee was formed to assemble gift packages to send overseas.

Here is an excerpt from a thank-you letter written on Wednesday, April 18, 1945, from Island "X" somewhere in the South pacific by Lt. (jg) S. E. Stevens:

> I do thank you all most sincerely, those of you who contributed your valuable time and labor so freely, and those who contributed in a financial way. Both contributions represent in my mind a definite degree of sacrifice by you good people back on the home front who are doing such a bang-up job keeping us in sufficient supplies and keeping our spirits up where we can feel that we really have something to fight for—home—and the people back there who make home worthwhile. Those people are not only our immediate families, but our neighbors, our townsfolk. They all go to make a pattern of life worthwhile to us, a pattern to which we all yearn to return at the earliest possible moment. Two years, ten thousand miles from home is a long time in anybody's book—much too long—but it cannot be helped, and I'm in high hopes that it will not be a great while longer before I'm homeward bound for at least a short visit. It cannot be too soon.

Today, our loved ones are still overseas, training and defending. Among them is Army Ranger Michael Feeley, recipient of a special time-honored tradition, reserved for the best of the best.

THE SOLDIERS' MONUMENT. The picture above shows our patriotism at the Soldiers' Monument in Mary Wales Holbrook Park. On the days designated to honor the people that serve our country, flags are respectfully placed in the park. The picture below shows the dedication ceremony of the Soldiers' Monument on May 30, 1917. Note the clothing. (Above, photograph by Steve Conley.)

**THE GRAVE OF GEORGE M. LOVERING IN UNION CEMETERY.** George M. Lovering received the Congressional Medal of Honor in the Civil War. (Courtesy of Wesley Cote collection.)

**A WORLD WAR I VETERAN.** John Winthrop Holbrook, son of John Farrington Holbrook, is pictured here during his service in World War I. His brother Ralph was the park commissioner in town. John's father is the man who wrote the diary from which the quotation in chapter four is taken.

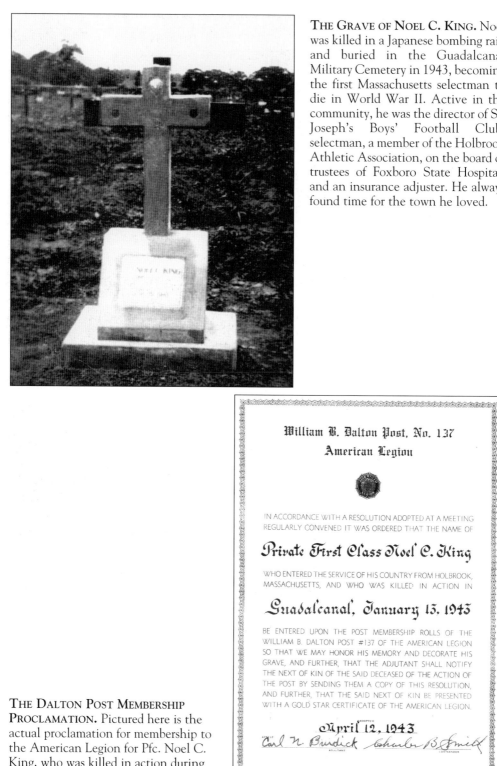

**THE GRAVE OF NOEL C. KING.** Noel was killed in a Japanese bombing raid and buried in the Guadalcanal Military Cemetery in 1943, becoming the first Massachusetts selectman to die in World War II. Active in the community, he was the director of St. Joseph's Boys' Football Club, selectman, a member of the Holbrook Athletic Association, on the board of trustees of Foxboro State Hospital, and an insurance adjuster. He always found time for the town he loved.

**William B. Dalton Post, No. 137**
**American Legion**

IN ACCORDANCE WITH A RESOLUTION ADOPTED AT A MEETING REGULARLY CONVENED IT WAS ORDERED THAT THE NAME OF

*Private First Class Noel C. King*

WHO ENTERED THE SERVICE OF HIS COUNTRY FROM HOLBROOK, MASSACHUSETTS, AND WHO WAS KILLED IN ACTION IN

*Guadalcanal, January 13, 1943*

BE ENTERED UPON THE POST MEMBERSHIP ROLLS OF THE WILLIAM B. DALTON POST #137 OF THE AMERICAN LEGION SO THAT WE MAY HONOR HIS MEMORY AND DECORATE HIS GRAVE, AND FURTHER, THAT THE ADJUTANT SHALL NOTIFY THE NEXT OF KIN OF THE SAID DECEASED OF THE ACTION OF THE POST BY SENDING THEM A COPY OF THIS RESOLUTION, AND FURTHER, THAT THE SAID NEXT OF KIN BE PRESENTED WITH A GOLD STAR CERTIFICATE OF THE AMERICAN LEGION.

*April 12, 1943*
ADOPTED

Carl N. Burdick     Charles B. Smith
ADJUTANT            COMMANDER

**THE DALTON POST MEMBERSHIP PROCLAMATION.** Pictured here is the actual proclamation for membership to the American Legion for Pfc. Noel C. King, who was killed in action during World War II.

108

**THE GIFT COMMITTEE.** The above picture, taken in December 1943, shows the teamwork of the committee as they filled necessity boxes to be shipped overseas to the hometown boys serving in World War II. A postcard was sent with a picture from home so the recipient could mail the return section to acknowledge receipt of the box. Shown below is the postcard. These return cards and letters were the gift of Fred Lutz and his wife, chairpersons of the committee, and are cataloged at the Holbrook Historical Society. The letters, postmarked from all over world, are on exhibit to read, and their contents will certainly touch your heart.

**WILLIAM B. DALTON (MARCH 10, 1894–MAY 1, 1918).** Dalton was killed in action May 1, 1918, in a German bombardment in France. In a large military funeral, his casket was placed on a caisson and drawn by six horses to St. Mary's Cemetery in Randolph where he was laid to rest. The inscription on his grave reads, "Soldier rest / Thy warfares over / Sleep the sleep / That knows no waking / Dream of battlefields no more." The American Legion Post No. 137 of Holbrook named their post in his honor in 1919, and also Dalton Road in the 1930s.

**HOME TO REST.** The body of William B. Dalton returns to Holbrook from France on April 2, 1921. A Solemn High Mass of Requiem was performed at St. Joseph's Church. Then the casket was placed on a caisson, which was drawn by six horses, and proceeded to St. Mary's Cemetery in Randolph.

**JOHN H. CARD III.** U.S. Air Force Lieutenant Card made 26 missions over France and Germany, receiving the Air Medal with three oak leaf clusters and the Distinguished Flying Cross. On June 20, 1944, in Algeria, he suffered severe injuries when a pistol being cleaned by a fellow officer was accidentally discharged. He died 10 days later and was buried in Tunis, Tunisia. He is the uncle of Andrew Card Jr. and is memorialized on the family stone in Union Cemetery.

**PFC. PAUL SURETTE.** Paul graduated from Holbrook High School with the class of 1964. He enlisted in the army and after training, volunteered as a paratrooper in September 1965 and was sent to Vietnam as a member of Company A, 503rd Infantry, 173rd Airborne Brigade, serving as a scout and a platoon leader. He was working as a first radio operator when he was killed in action while on a combat operation on June 29, 1966, after serving for three months in Vietnam.

**A Civil War Veteran.** This is a wonderful old picture showing Civil War veteran George Kent.

**A Time-Honored Tradition.** Michael Feeley was serving in Korea in 2001 and was deployed to the front line for a simulated combat exercise. Four-star general Schwartz, in command of all U.S. forces in Korea, witnessed his performance and singled him out for congratulations. The coin he presented to Michael is a symbol of a coveted mark of respect awarded by the most senior military officers dating back to the Revolutionary War.

# *Ten*
# HUMAN INTEREST

Events that reshape us occur daily in our lives, especially in a small town like Holbrook. Some are tragic, some are joyous, but the one thing we can be sure of is their effect on us. The pictures in this chapter depict a wide range of interesting moments and display a community bonding together in times of need.

There is no better example of people banding together than in April 1983, when our town leaders, in a unanimous vote, ousted the Baird and McGuire Chemical Company from town to the cheers of 1,000 residents. This was one human-interest story that made headlines nation wide as we started our cleanup of the toxic Superfund Site.

In this chapter you will find out why Charles Kuralt and Walter Cronkite were in town, who planted the Big Elm on the Adams Homestead, and see classic women's fashion of the 1800s in the Hayden Collection. Time repeats itself in the then-and-now photographs of a gazebo built at Sumner Field, first in 1914 and again in 2001.

We love to hear the stories that touch our hearts—Eileen Depson being pulled off the railroad tracks by her dog. And we love to see pictures that trigger nostalgic memories of our own childhood—the giant snowman in Mary Wales Holbrook Park. These photographs are icons of interest to us because they remind us of who we are. The stories behind them could be victorious or tragic, but they are the ones that exemplify the best spirit of our community.

No matter what your interest, the Holbrook Historical Society is a wonderful resource and conservator of town memorabilia. The society invites you to the little red schoolhouse to experience a step back in time and learn more about your town.

The photograph on the last page depicts the simple beauty of a snow-covered Union Street in 1906 and reminds us that "there's no place like home."

**A Quiet Time.** All alone on the road, a horse-drawn carriage rides through Holbrook during a snowfall.

THE HOLBROOK SQUARE. Shown from 1892 is the campaign flag of incumbent president Benjamin Harrison, and Whitelaw Reid, who was defeated by Grover Cleveland in the election. Cleveland's victory led to the Democrats regaining control of both chambers of congress. Harrison was known as the "Iceberg President" for his aloof behavior but ran what were called front-porch campaigns.

THE PLYMOUTH STREET BLOCK. The small building on the right, shown c. 1936, was a cobbler shop and visited by Pres. John F. Kennedy in 1958, while he campaigned for reelection to the U.S. Senate. In the fall of 1958, the building was the temporary headquarters of the Holbrook Democratic Town Committee. The block has since been torn down for Walgreens. Matt's Villa was housed in the building on the left for many years.

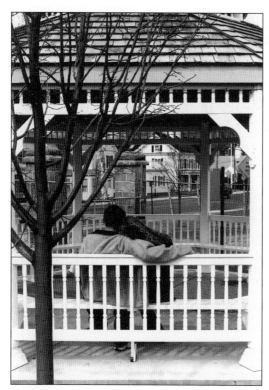

**THEN AND NOW.** The picture below shows the gazebo bandstand at the playground near Sumner School. Built in 1914, it was demolished c. 1946. Pictured to the left are Steve Civitarese and Amanda Albrecht remembering their friend Kris Carew (1982–2000) at the gazebo built in his memory at Castle Canyon playground, Sumner Field. (Left, photograph by Patrice Lynch; below, courtesy of Wesley Cote collection.)

**THE PLANE CRASH.** This photograph shows a piece of disintegrated jet that was piloted by naval reservist Lt. Walter Heins on October 4, 1967. Credited with guiding the failing plane away from the thickly settled area, Heins died in the crash off Pond and Weymouth Streets, narrowly missing the propane tank at the mobile trailer park. Newscasters Charles Kuralt and Walter Cronkite came to Holbrook to cover the story. Holbrook residents raised more than $12,000 for a trust fund for his 10-day-old newborn son in memory of the man they considered a hero.

**STABLES ON SYCAMORE STREET.** Fred Bellows and his wife are shown here *c.* 1915 with their prized race horses. (Courtesy of Wesley Cote collection.)

THE UNION STREET CEMETERY. The gravestone of Nathaniel Pratt, who died *c.* 1759, is made of red slate and is the oldest stone in Union Cemetery. Nathaniel was a veteran of the French and Indian War. The other stone belongs to Capt. Elihu Adams, a Revolutionary soldier and captain of a company of Minutemen who participated on the Lexington-Concord green on April 19, 1775. Elihu was the brother of Pres. John Adams and the uncle of Pres. John Quincy Adams. He built his home on the land where present-day D'Anns Restaurant is located at 200 South Franklin Street and died on August 10, 1775. (Courtesy of Wesley Cote collection, composite by Steve Conley.)

THE HOLBROOK FAMILY BURIAL LOT. The Holbrook family burial lot is shown here at Union Street Cemetery. (Courtesy of Wesley Cote collection.)

**CHARLES DORNAN, NOTED MAGICIAN OF HOLBROOK.** Shown here *c.* 1910, Charles worked with Houdini at one time and was the father of entertainers Leo and Charles. He also developed patents for shoes used by Barbour Welting Company in Brockton. (Courtesy of Wesley Cote collection.)

*The* Dornan Brothers

**Gentlemen of Comedy**

COMEDY — SINGING — DANCING —

AUDIENCE PARTICIPATION —

COMEDY SKITS —

IMPRESSIONS —

PANTOMIME

A complete show with the DORNAN BROTHERS

**THE DORNAN BROTHERS PLAYBILL.** Pictured is a playbill of the famous Dornan Brothers who entertained the troops in World War II. Leo married Annabell Crandall, a singer with the Metropolitan Opera who was serving as a member of the Women's Army Corps. Their daughter, Patricia, is married to Michael Herbert, choral director at Holbrook Junior-Senior High School.

**THE HOLBROOK LAKE BEACH.** Enjoying a leisurely swim at the grove beach in 1952 are Dot Monroe (left) and Jean Cross (right). Many former students will recognize Jean since she worked many years as a cafeteria worker in the school system.

**THE RETURN OF THE TURTLES.** Anyone who lives in the grove on Lake Holbrook knows to drive slowly due to the unusual pedestrians in July and August. Each year female turtles of many types, some quite large, make their way to land to lay their eggs in approximately the same spot they did the year before. The lake is a wonderful area to walk, canoe, and observe wildlife. (Photograph by Patrice Lynch.)

**THE ECHO BRIDGE.** Shown here is a popular postcard image of Echo Bridge. Echo Bridge crossed a small stream that connected to Sylvan Lake and is located in the present-day Water Street area.

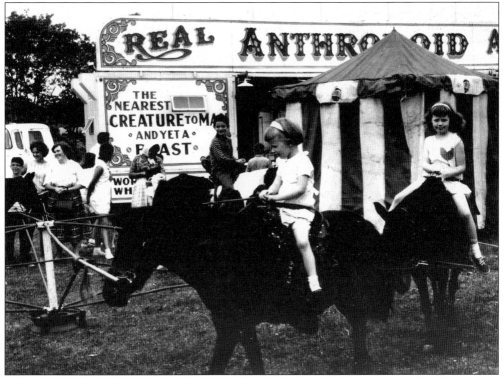

**THE REAL ANTHROPOIDS.** Shown here is the children's pony ride at the Mills Brothers Circus when it came to Holbrook on August 1, 1962. (Courtesy of Wesley Cote collection.)

**PRINCE, HOLBROOK'S HERO DOG.** The dog saved Eileen Depson's life by pulling her off the railroad tracks from the path of an oncoming train on October 18, 1929. The Depson family lived on Centre Street near the scene of the accident. The event was reported in the Boston paper. The family, with the dog, were invited to a special ceremony in Boston, honoring the dog's heroic act. Eileen grew up in Holbrook, later married, and moved to Avon.

**REX.** Rex was the dog of Chief of Police Walter Crooker. Rex pulled another dog off the tracks in front of an electric car in 1913. (Courtesy of Wesley Cote collection.)

**HOLBROOK HISTORICAL SOCIETY WINTER SOCIAL.** This event from February 28, 1981, was held in celebration of the town's so-called un-birthdays. Shown in the photograph are, from left to right, Nell Connelly, Alice Graziano, Joyce Card, Rita Smith, Edna Bowers, Polly McLaughlin, and Janice Brodil.

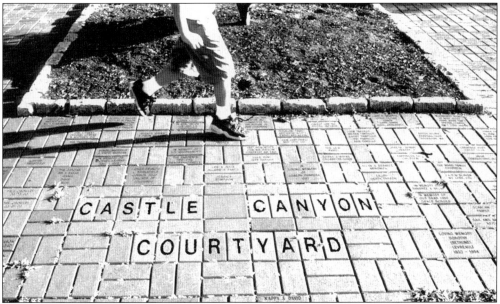

**CASTLE CANYON.** Installed on the site of the original Sumner High School, the Castle Canyon Playground was conceived and built by an energetic and dedicated group of young parents. In 1995, they organized a series of fund-raisers, including a golf tournament, selling candles, and inscribed paving bricks, among other projects. In one weekend in 1997, the project was installed by the volunteers, providing a safe and attractive play area for Holbrook's children. (Photograph by Steve Conley.)

**LAYING THE NEW TIME CAPSULE.** The grand master of Masons, Donald Vose of Wellesley Hills, placed a copper box in the cornerstone of the town hall where it will remain for 100 years. The majestic Masonic ceremony included many guest speakers. The invocation was presented by Rev. Richard Crowley of St. Joseph's, and the benediction by Rev. Gary Smothers of the Winthrop Congregational Church. The Holbrook Junior-Senior High School band played under the direction of Edmund Myers.

**THE LITTLE PATRIOT.** This unidentified person is known as the little maid who unfurled the flag at Holbrook Town Hall, July 4, 1909.

THE HAYDEN COLLECTION. A lovely and well-preserved walking dress is shown here from the collection donated by the Hayden family to the Holbrook Historical Society. The Hayden Collection includes many items of clothing dating back to the 1800s, which demonstrate exquisite crocheted lacework and can be seen at the historical society.

**WEEKS GASOLINE STATION.**
These *c.* the late 1940s pictures are of Weeks gasoline station at 114 Franklin Street, which was managed by W. W. Murray. Murray has been involved in Scouting for 54 years and is now an assistant district commissioner in Scouts. Note the Boy Scout badges displayed in the window.

**AN OLD-FASHIONED PICTURE.**
Pictured here is little Ethel Bates
Sprague, age three years, nine
months, in April 1889.

**LET IT SNOW, LET IT SNOW.**
A giant snowman is shown in
Mary Wales Holbrook Park
after the great storm on
February 4, 1961. (Courtesy of
Wesley Cote collection.)

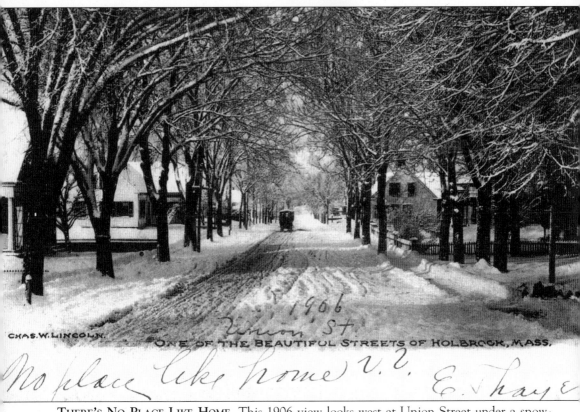

CHAS. W. LINCOLN.

ONE OF THE BEAUTIFUL STREETS OF HOLBROOK, MASS.

*1906*

*Union St.*

*No place like home* v. v.

*E. Thaye*

**THERE'S NO PLACE LIKE HOME.** This 1906 view looks west at Union Street under a snow-covered arch of magnificent elms.